About the artist: Donald S. Castro

Don Castro was born in Chicago, Illinois. It was during his childhood in Chicago that art became an important part of his life. He attended weekend and evening classes at the Art Institute of Chicago from the age of nine until his late teens.

Upon graduation from high school, a career in art was put on hold when he joined a major food manufacturing company which changed his focus from art to engineering. He retired as a Director of Manufacturing after thirty nine years
 of service. Throughout those years he had been active in art and has since been able to devote full time to his artistic endeavors.

Sketching and photographing various subjects in his travels throughout the country have provided the material from which he produces his work in his Naperville,
Illinois home and studio.

Don enjoys the challenge of working in most media including acrylics, oils, mixed media, pen and ink, watercolor and gouache. His subject matter encompasses a wide range of interests from landscapes and botanical art to spiritual art and impressionism. His commission work has ranged from works of art on paper and canvas to the design and fabrication of custom woodworking projects, the restoration of wooden reliefs and statues for individual clients and several religious organizations. He is a member of the Naperville Art League, and a member and past president of the Nature Artist' Guild of the Morton Arboretum in Lisle, Illinois.

I hope that you enjoy coloring the pages of my botanical art as much as I enjoyed drawing each of them.

To view the full range of my art, visit my website at:
www.donaldcastro.com

"When we love, we always strive to become better than we are. When we strive to become better than we are, everything around us becomes better too."

— Paulo Coelho

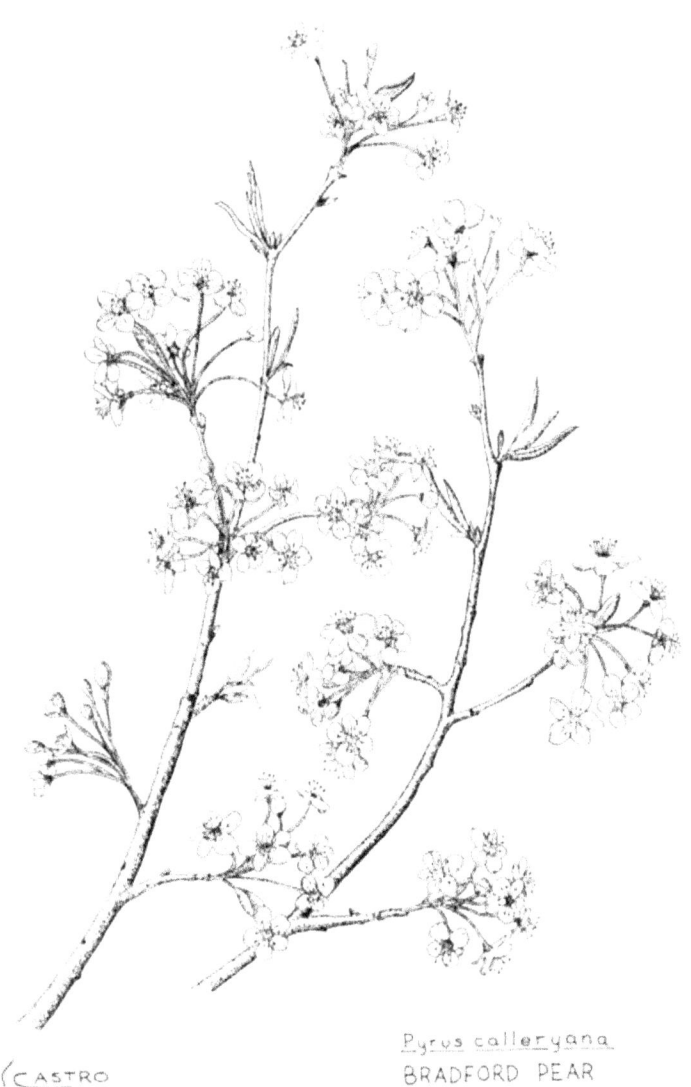

Pyrus calleryana
BRADFORD PEAR

D/CASTRO

Patience and perseverance have a magical effect before which difficulties disappear and obstacles vanish.

___ John Quincy Adams

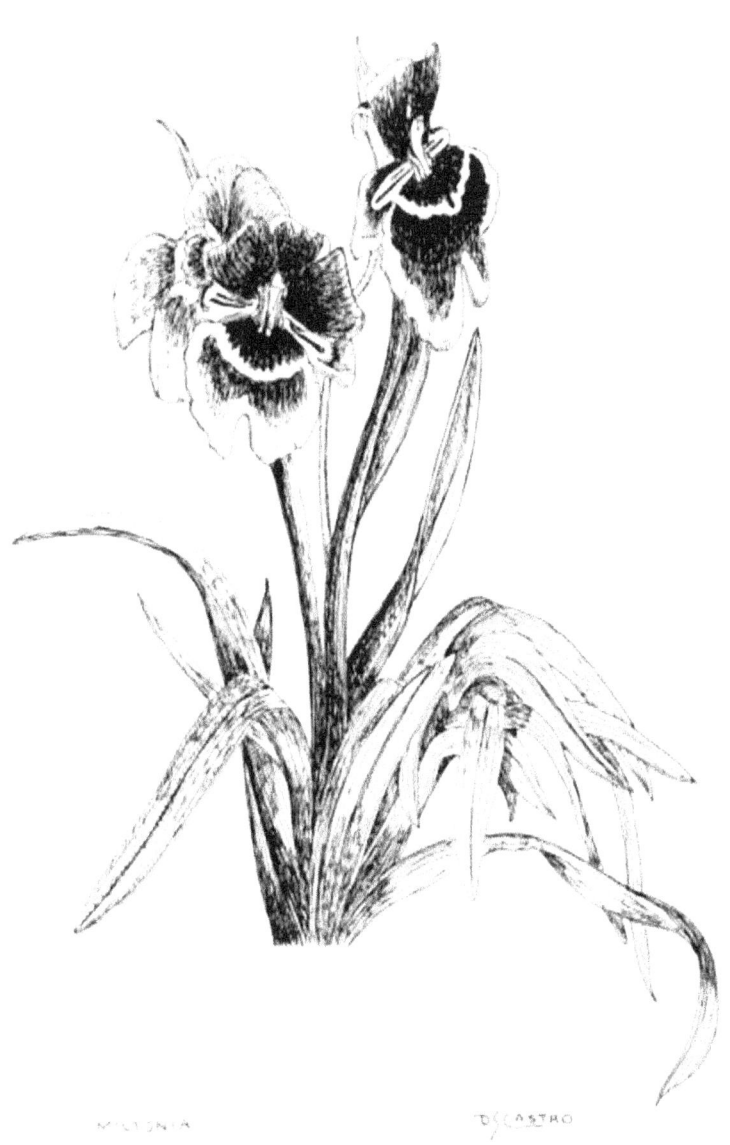

Now and then it's good to pause in our pursuit of happiness and just be happy.

— Guillaume Apollinaire

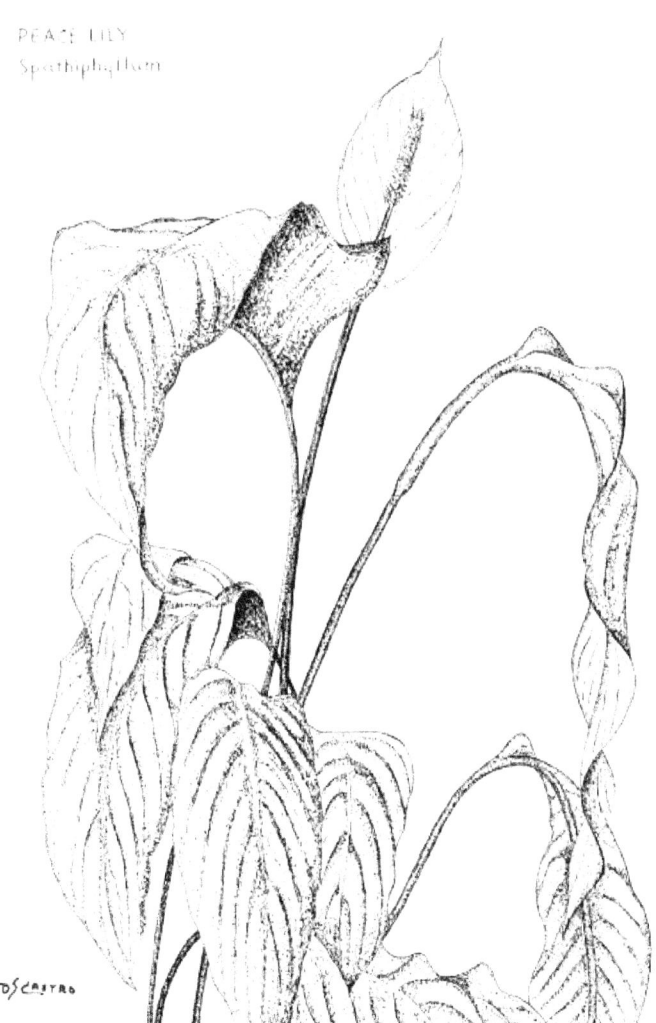

PEACE LILY
Spathiphyllum

Treat yourself like a special person
 Because
 You are one.

 ___ Maria Mullins

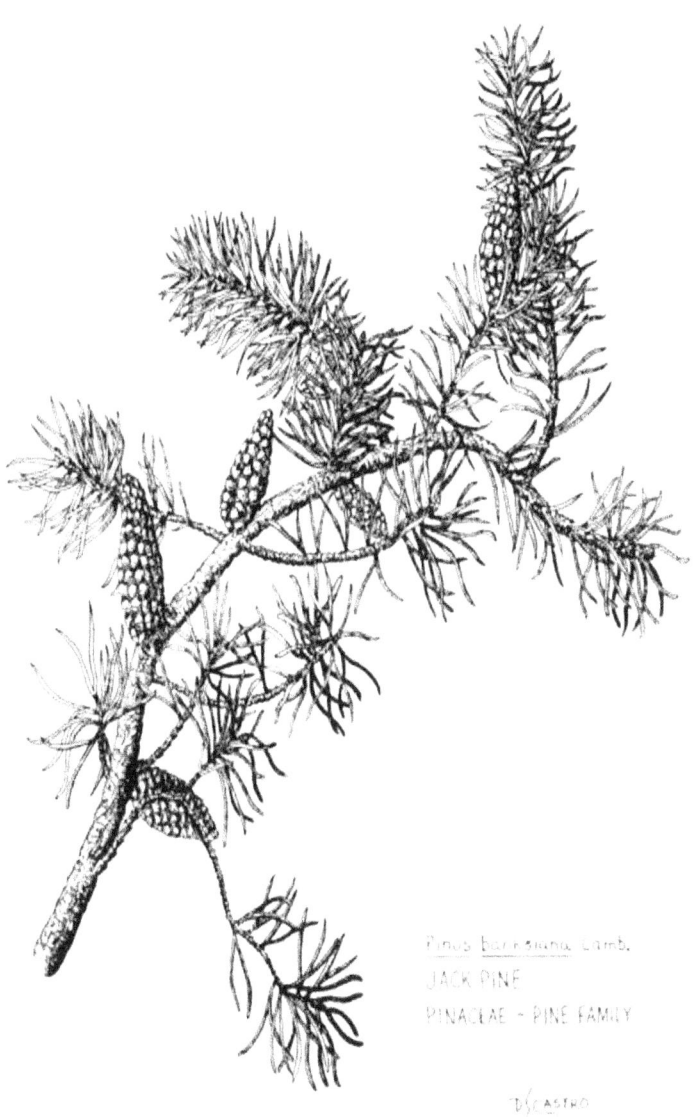

The only real mistake we make is the one from which we learn nothing.

___ John Wesley Powell

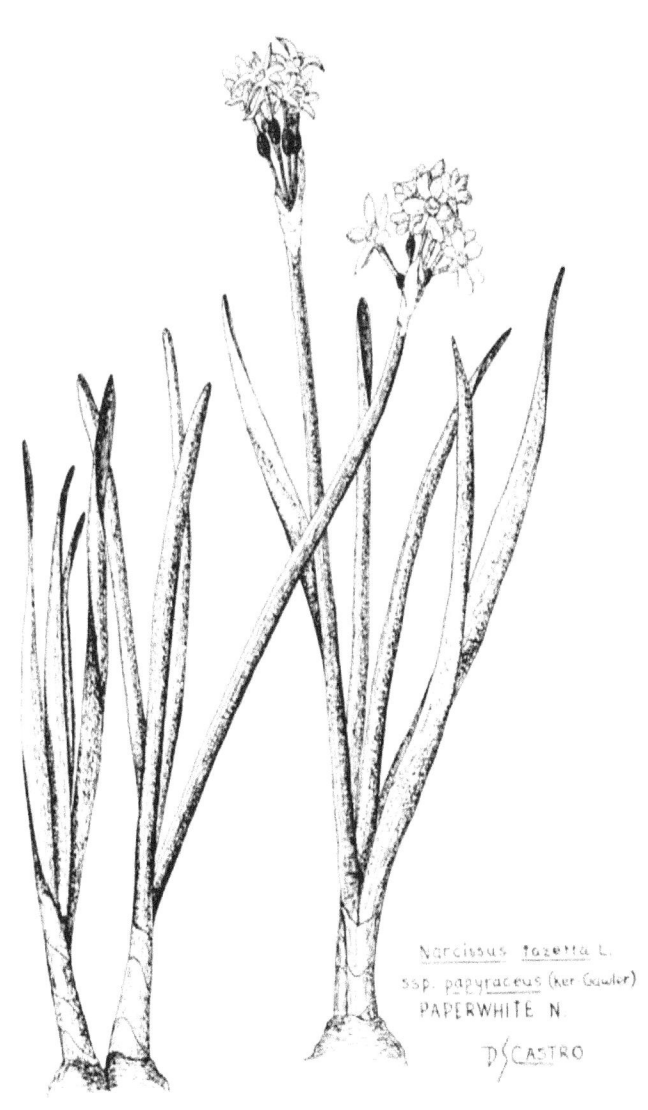

The spirit within us cannot be tamed if we continue
to believe in what makes us unique and beautiful.

___ MEH

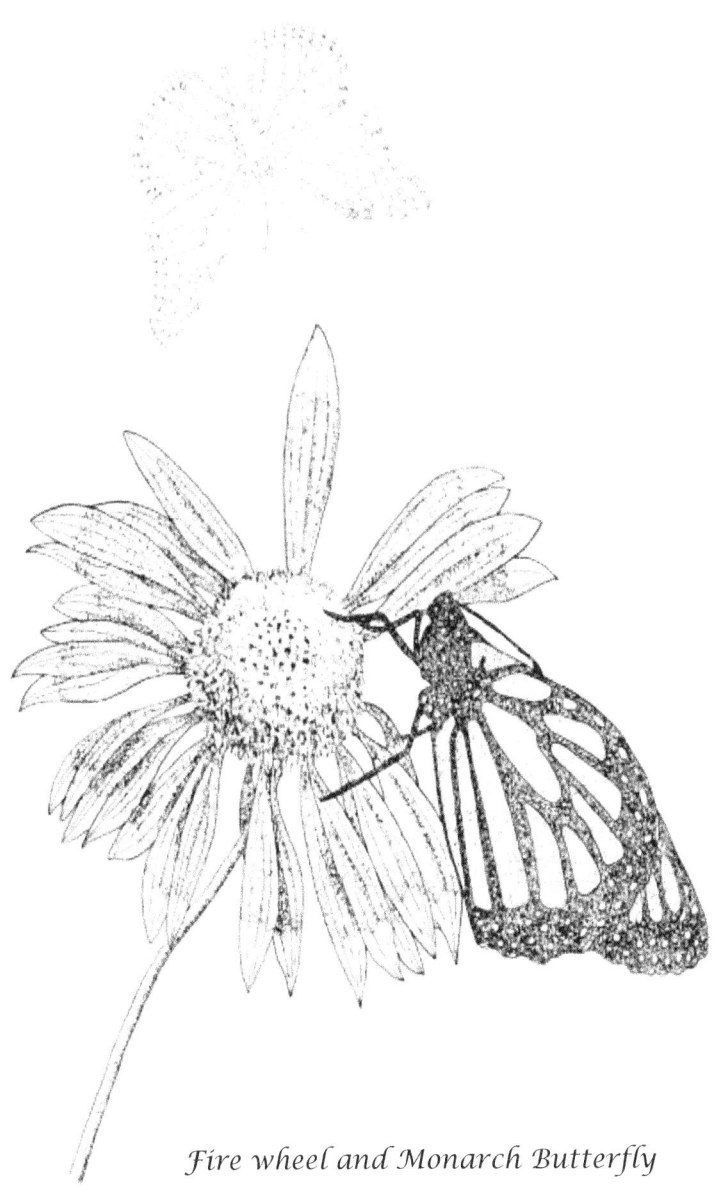

Fire wheel and Monarch Butterfly

Believe in yourself for this will bring you closer to peace.

— MEH

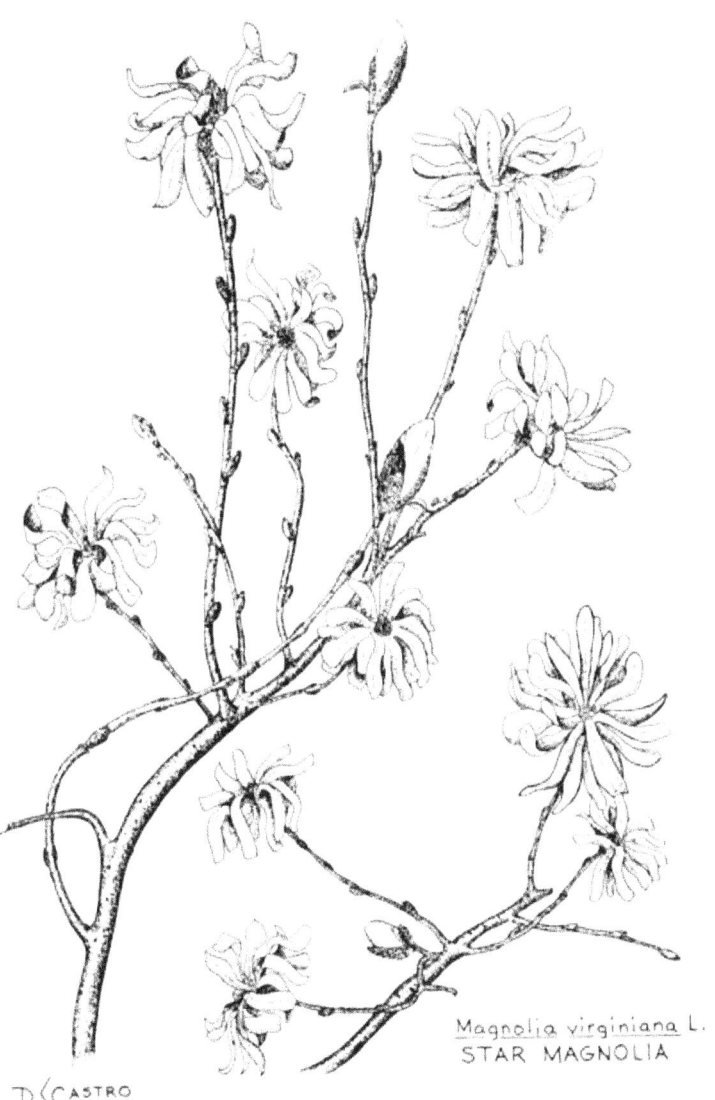

Magnolia virginiana L.
STAR MAGNOLIA

What is Attitude?
 Purpose
 Determination
 Love
 Faith
 Attitude is who you are and how you live life.

　　　　　　　___ MEH

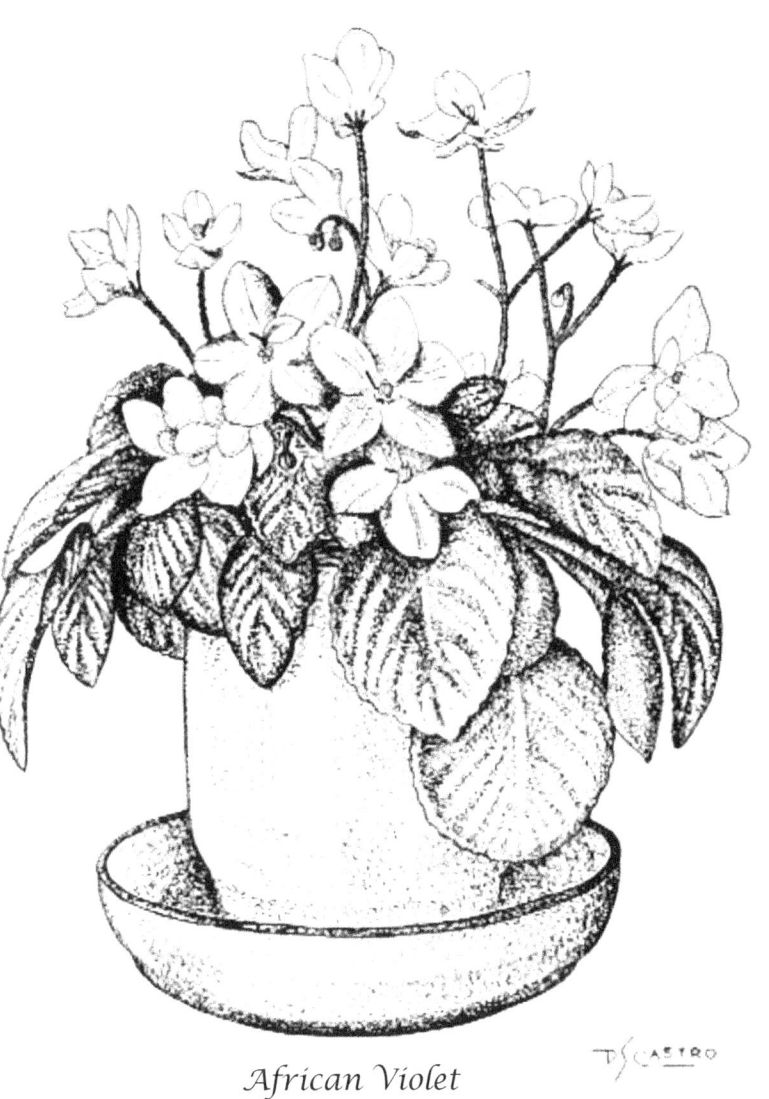

African Violet

Strength and confidence......

The kind that comes from those experiences that teach you that you can rely on yourself and you do have something to say about your destiny

___ Deeva D. Boleman

Lythrum salicaria
PURPLE LOOSESTRIFE

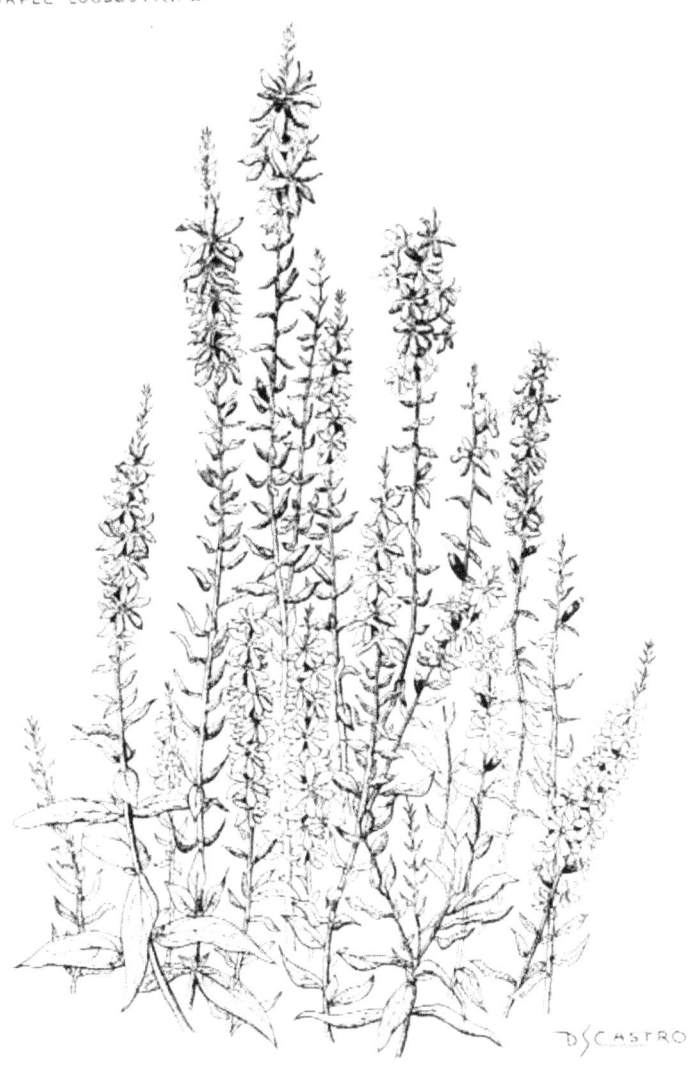

"What you do makes a difference, and you have to decide what kind of difference you want to make."

___ Jane Goodall

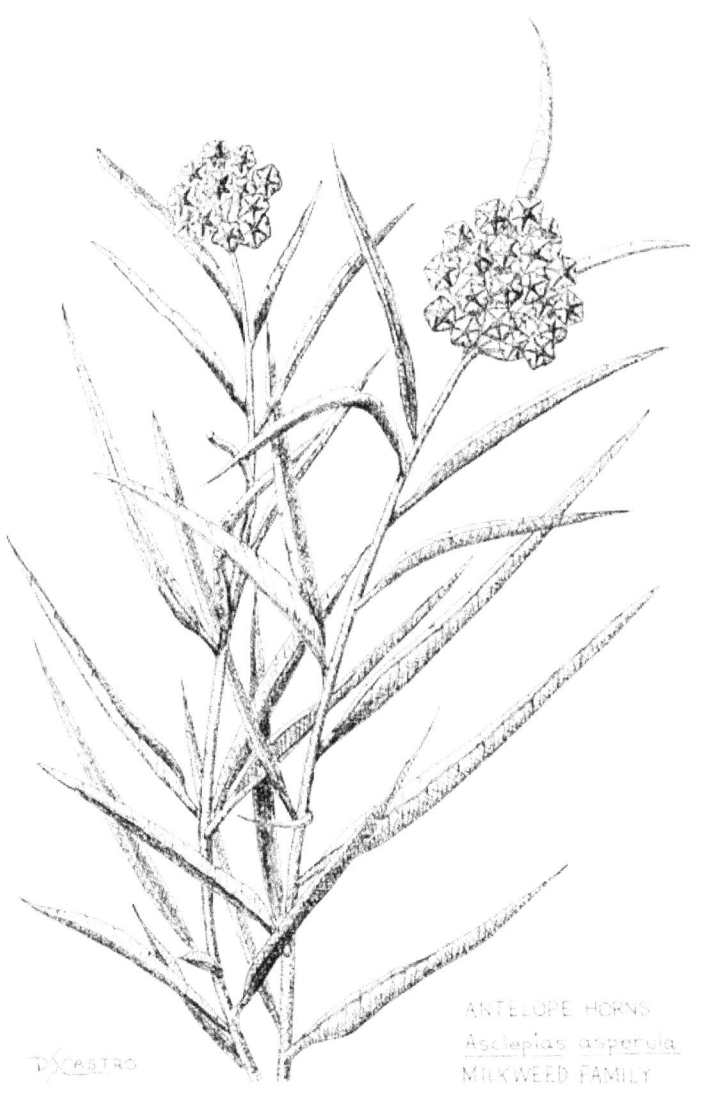

ANTELOPE HORNS
Asclepias asperula
MILKWEED FAMILY

Keep away from people who try to belittle your ambitions. Small people always do that, but the really great make you feel that you, too, can become great.

 ___ Mark Twain

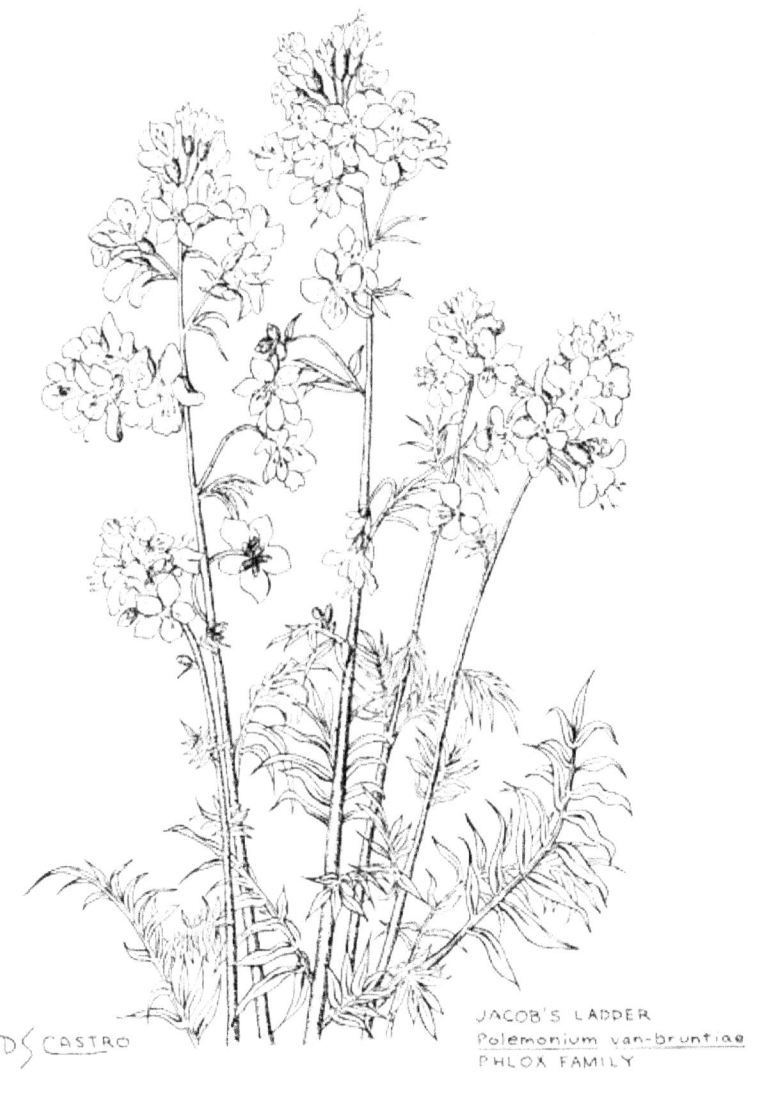

Stay true to yourself!

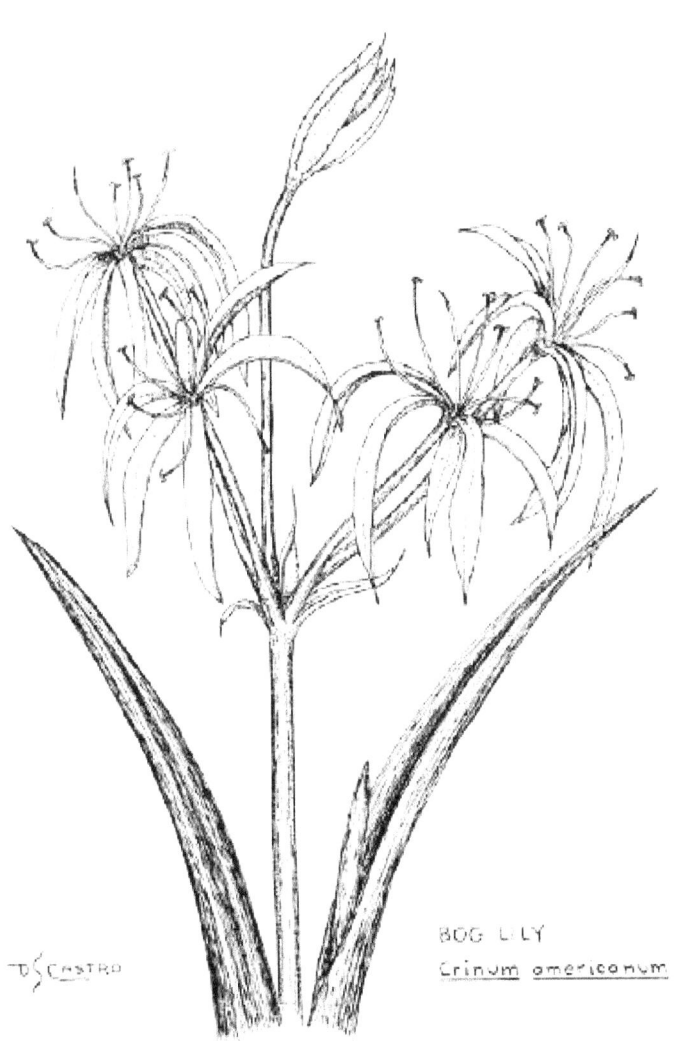

BOG LILY
Crinum americanum

The best and most beautiful thing in the world cannot be seen or even touched – they must be felt with the heart.

___Helen Keller

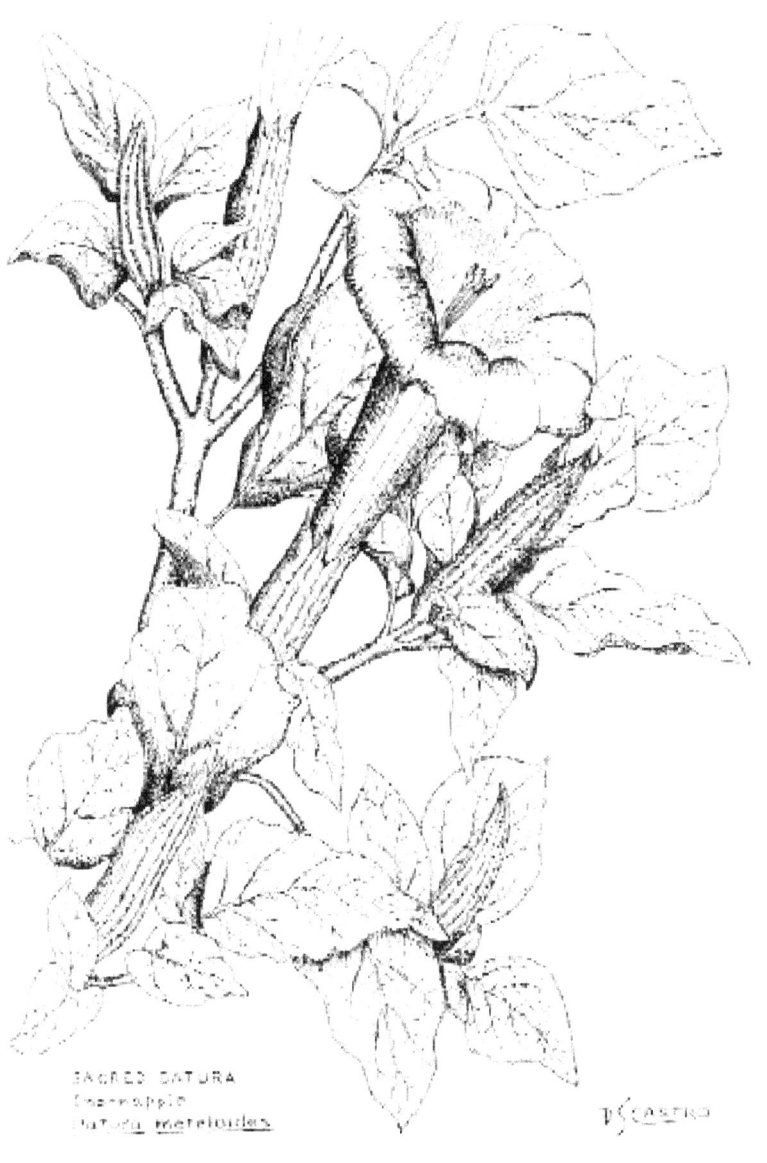

SACRED DATURA
Thornapple
Datura meteloides

"You don't need to change the world; you need to change yourself."

__Miguel Ruiz

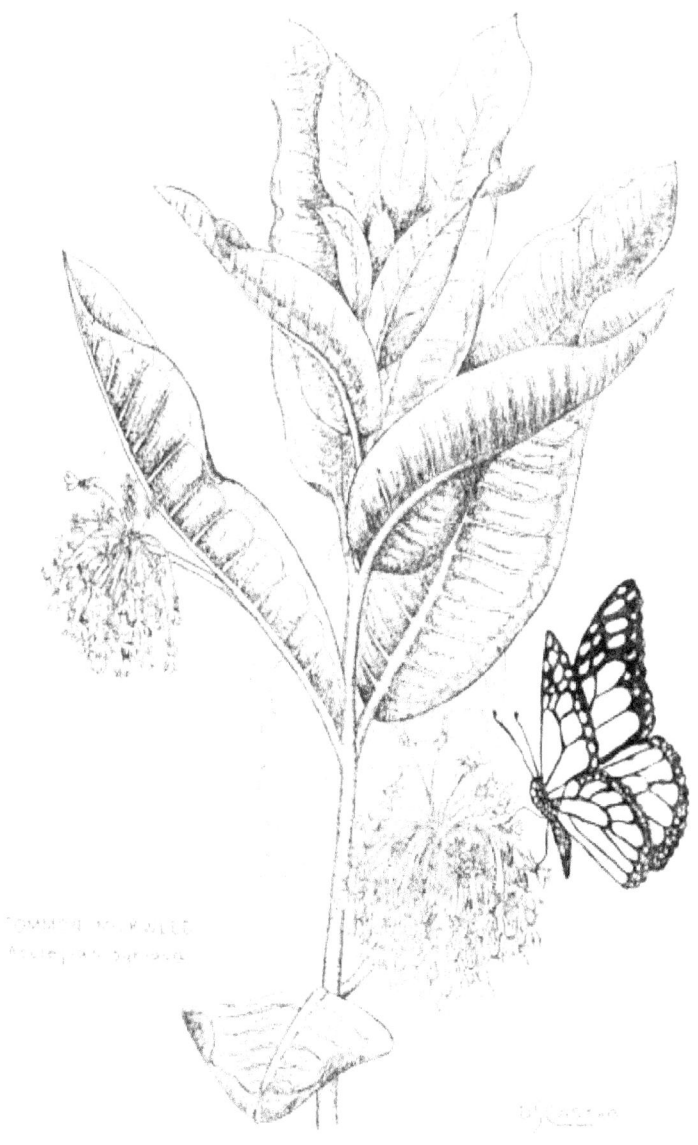

Look deep into nature, and then you will understand everything better.

⎯⎯ Albert Einstein

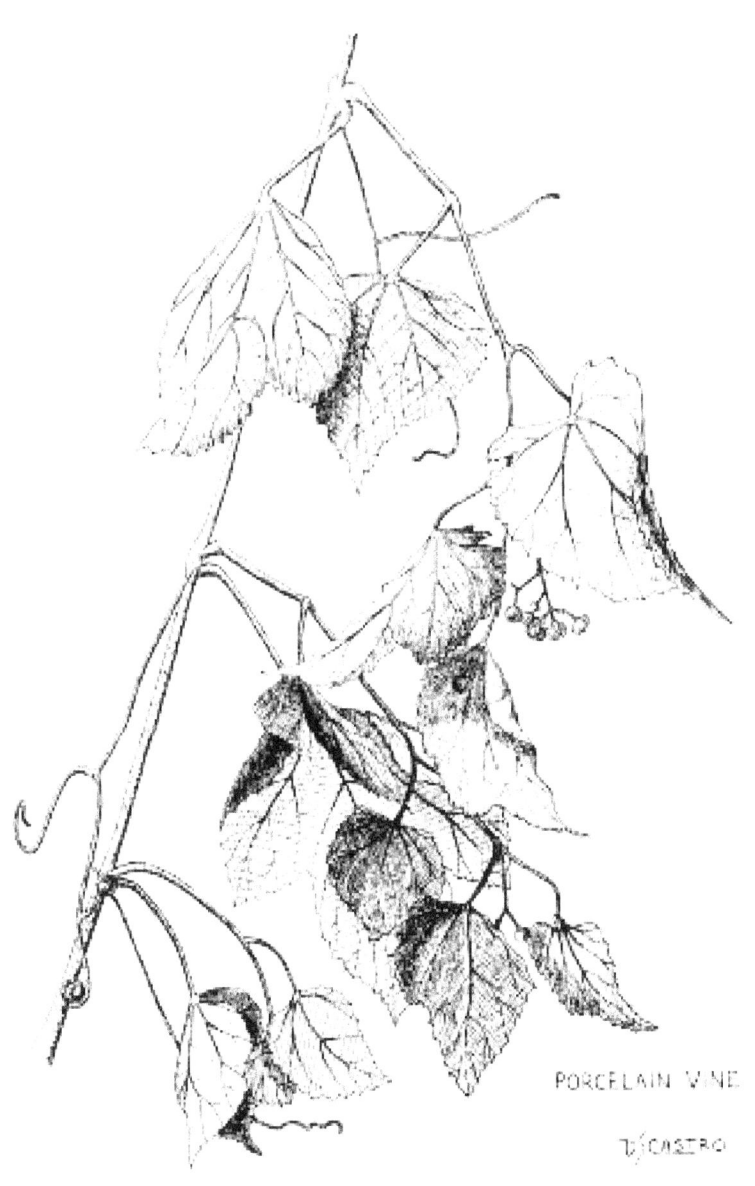

Self-confidence is the primal source of your success; it can ultimately be more important than anything else you bring to bear on an issue. Whatever you're doing, act as if you cannot fail - and you'll be amazed by the results you get.

 ___ Author Unknown

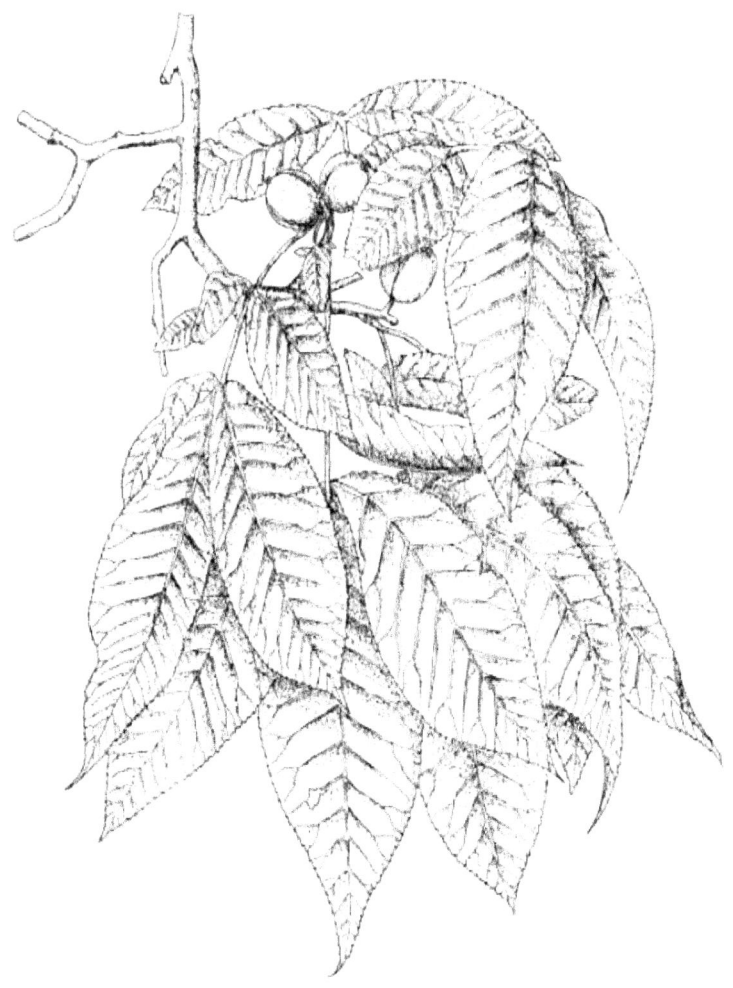

SHAGBARK HICKORY
Carya ovata

D. CASTRO

Help each other win and take pride in each other's victories.

— Ian Percy

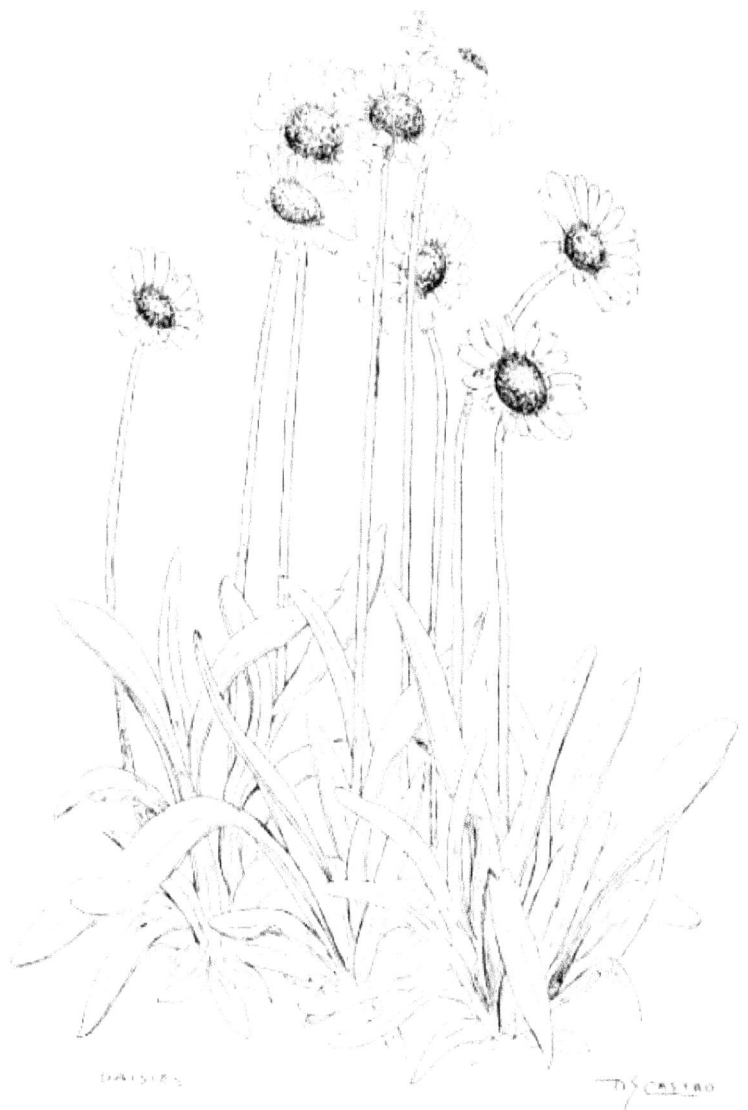

Our real blessings often appear to us in the shapes of pains, losses, and disappointments; but let us have patience, and we soon shall see them in their proper figures.

___ Joseph Addison

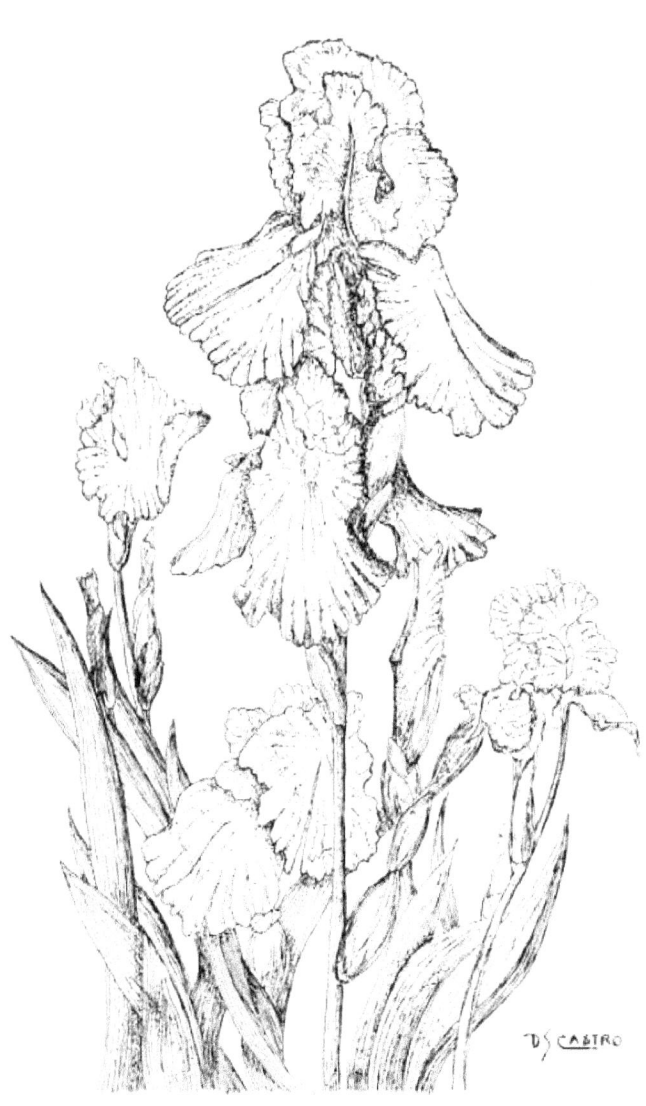

Irises

Always strive for freedom and peace.

 ___MEH

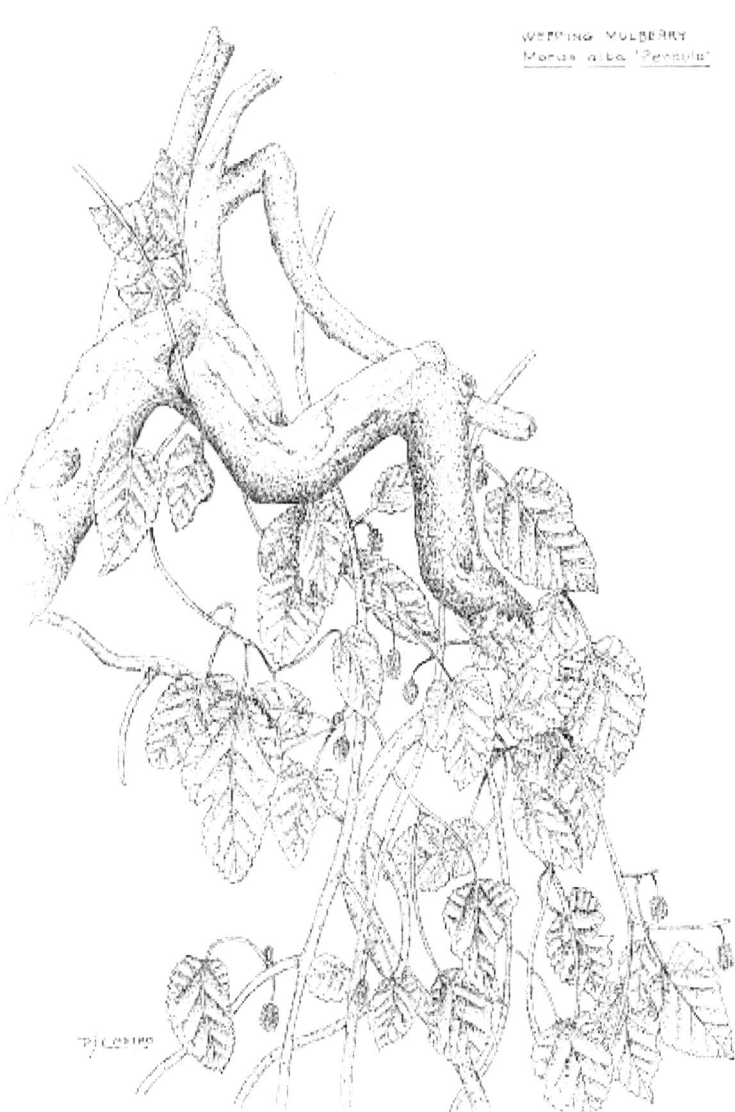

WEEPING MULBERRY
Morus alba 'Pendula'

Respect yourself and you will respect those that earn it.

— Author Unknown

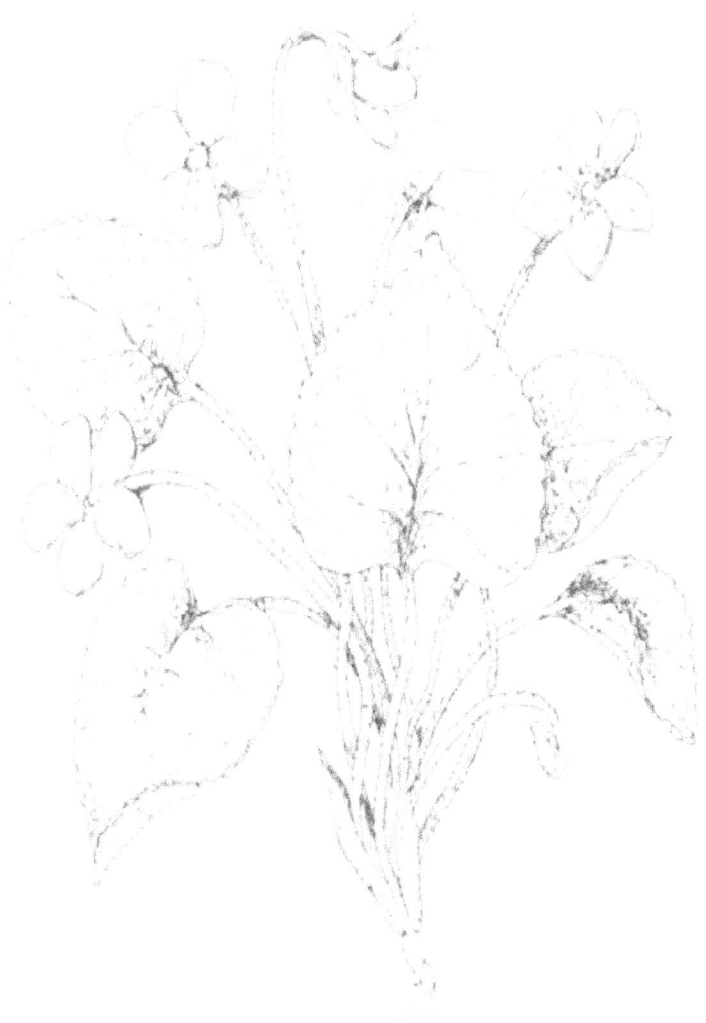

Blue Violet

HOPE!

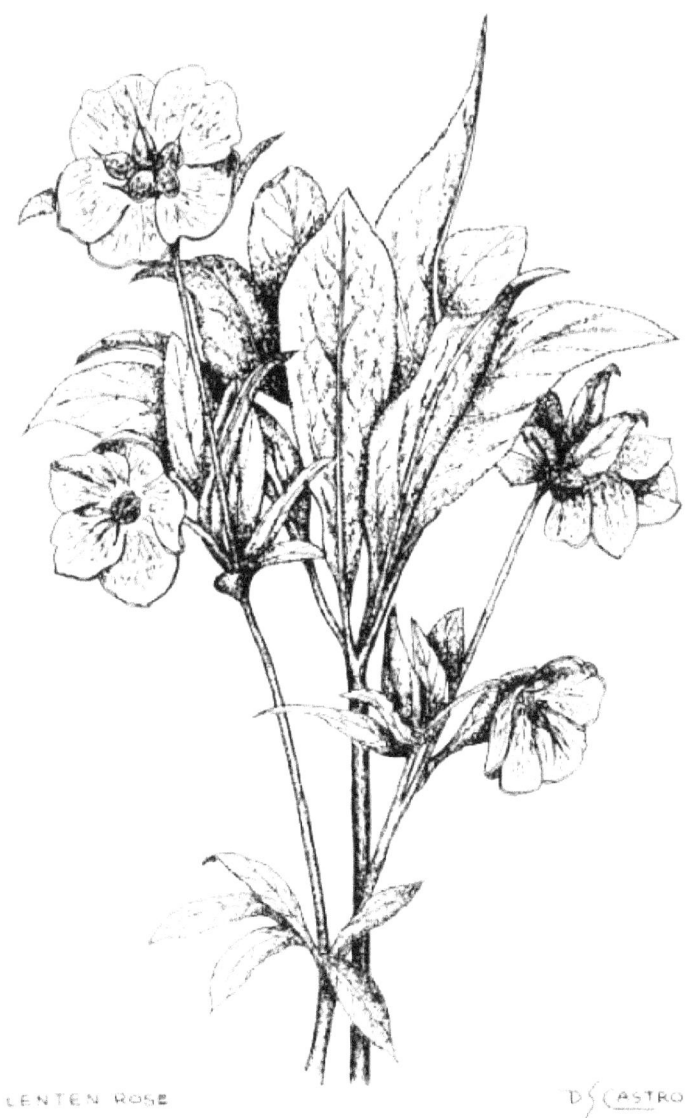

LENTEN ROSE

The best way to cheer yourself up is to try to cheer somebody else up"

___ Mark Twain

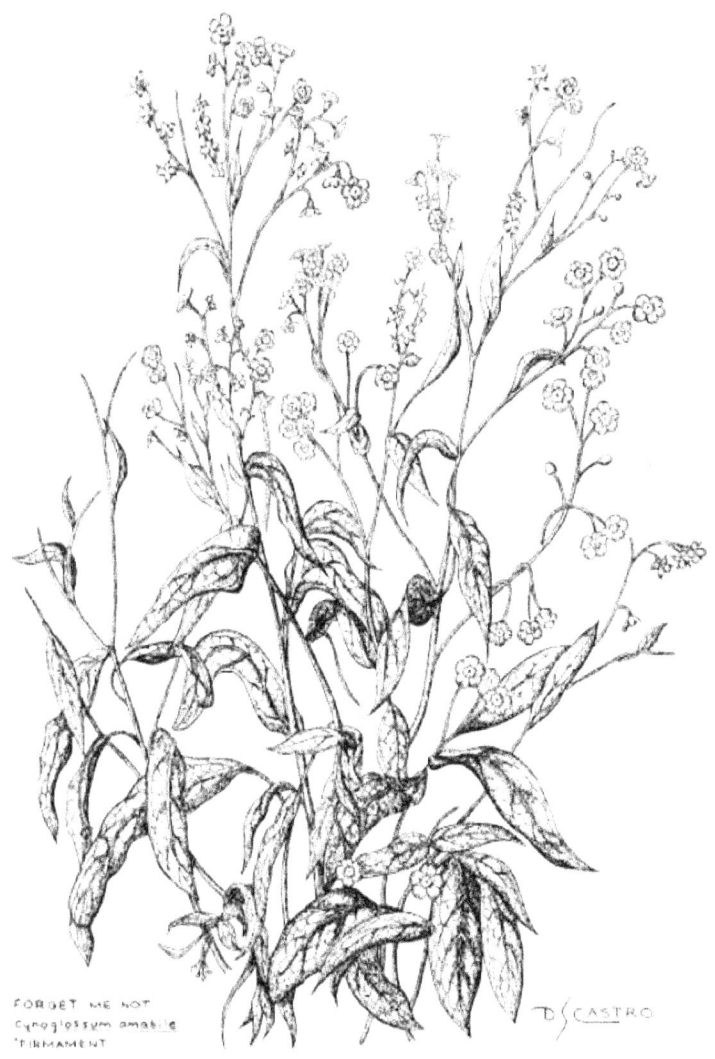

There is a power for good in the universe
and you can use it.
 ___ Ernest Holmes

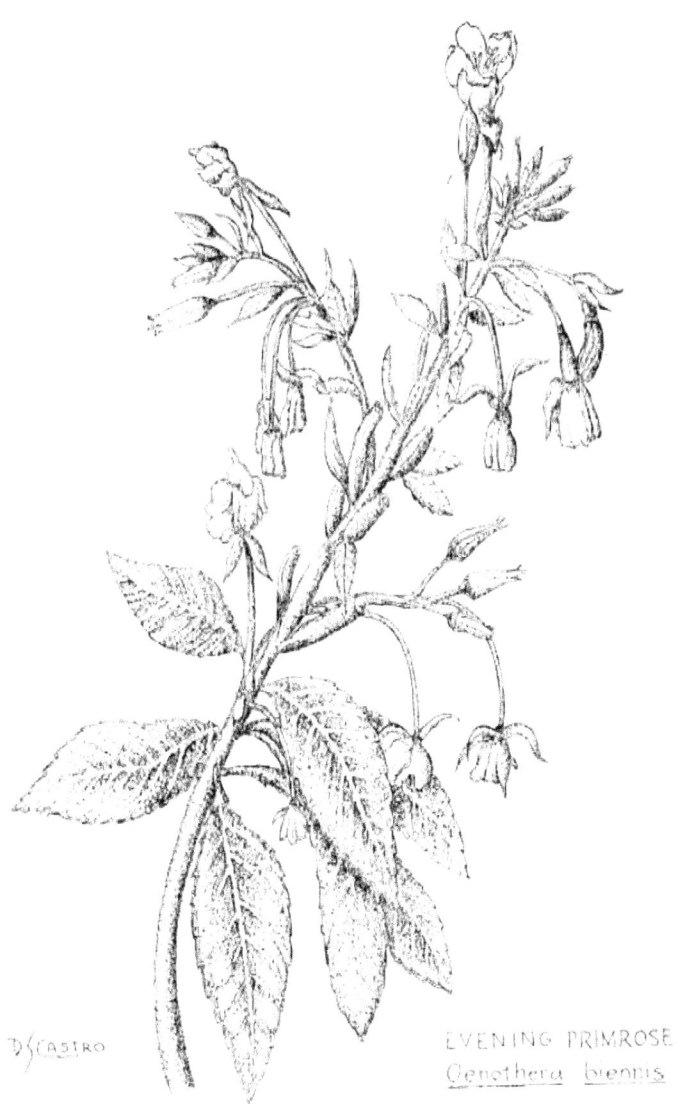

EVENING PRIMROSE
Oenothera biennis

"Forgiving is not forgetting, it's letting go of the hurt"

___ Mary McLeod Bethune

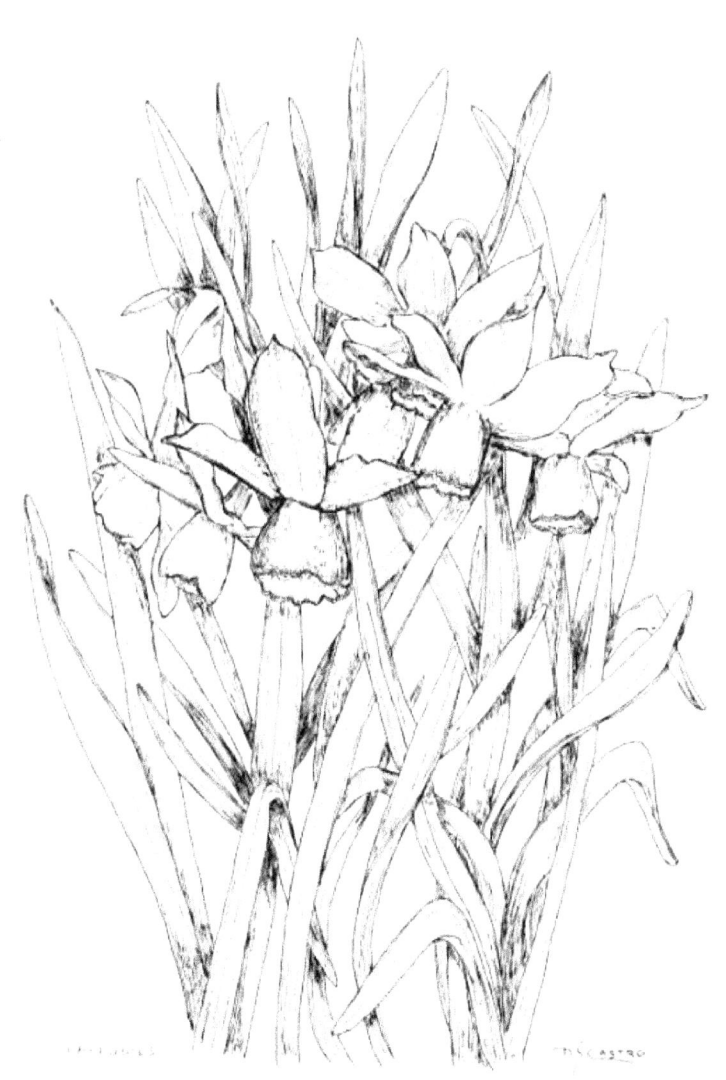

www.ingramcontent.com/pod-product-compliance
Lightning Source LLC
Chambersburg PA
CBHW070227210526
45169CB00023B/1233